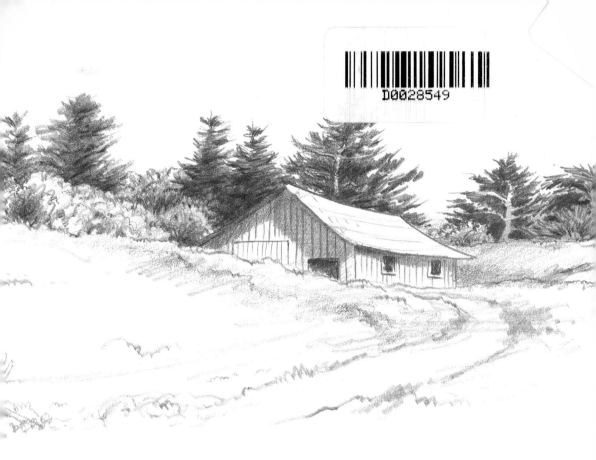

PENCIL DRAWING

BY GENE FRANKS

Walter Foster Publishing, Inc.
430 West Sixth Street, Tustin, CA 92680-9990

Table of Contents

Introduction

Now that you have picked up this book, don't put it down! You are in for a treat. The sensitive drawings you see here will encourage you as an aspiring artist. The poetic beauty and softness of these pieces are compelling. I fell in love with each one as it emerged from the artist's pencil, just as I think you will as you leaf through the book.

Gene Franks takes pencil further than many artists, bringing out fine detail and subtle contrast of texture and shading. Along with teaching his techniques, Gene brings to these pages his homespun philosophy and propensity for old things. He is generous in sharing his insights, eager to help the serious student as well as the one who can devote just an hour or two each week for personal enjoyment. He constantly shows by personal example the way to handle the pencil, and the way to see beauty in ordinary things. His dogged perseverance in striving for perfection has inspired hundreds of students. One of them recently wrote him a note. She applied this quote to him as her teacher, "If he is indeed wise, he does not bid you enter the house of his wisdom, but rather leads you to the threshold of your own mind." That is Gene's concept of learning to draw. "No one can teach you," he has said. "I can provide the tools but you must teach yourself."

Gene does not attempt to exhaust the subject of pencil drawing in one small book. That would be impossible. His greatest desire is to get you started; to infuse new excitement into your work.

As you can tell, I know Gene Franks very well. I have watched him struggle over the years, and I've seen his work gather recognition. I've observed with pride and gratification the growing number of people who like his work. I'm thrilled to introduce you to Gene Franks in this, his first book, for you see, he is my husband and teacher. I was one of his students. He taught me to draw, and I know he can teach you, too.

Wherever you are in the process, this wonderful book will inspire you to keep trying, to keep growing, to become the best pencil artist that you can possibly be. Read on!

Jane W. Franks

3

Why Draw?

Pencil is the basis for all other media. It is important, therefore, that every artistic person learn to draw. As you master this medium, other creative fields will open up to you.

Pencil is a portable, economical art form. It requires just a few simple tools. Pencil is an enjoyable experience. When I taught drawing, I saw that by following a few basic principles, and by faithfully practicing, the students soon handled the pencil with ease.

Learning to draw teaches you to see the world around you with more awareness. It trains you to observe correctly, and improves the dexterity of your mind and hands.

As a young artist, I filled many sketch pads, drawing everything I could find. In art school, we drew from sight daily. Through the years, my paintings have improved because of the background I received in my drawing classes.

The old masters used the pencil as a sketching medium, but today it is much more. Pencil drawing has come into its own. Finished pencil drawings by professional artists are appearing in major art galleries across the country.

Soon you, too, will want to mat and frame some of your drawings to hang on the wall or give to friends. I believe that the wonderful art of pencil drawing can bring personal fulfillment and joy to your life.

Materials

The following materials were used to produce the drawings in this book.

Pencils. The ordinary lead pencil is my favorite because it is easily controlled. The degree of hardness is governed by variable amounts of clay mixed with graphite. The softest pencils have little or no clay. The hardness is indicated by a letter and number combination printed on the head of the pencil. The scale begins with the H's which are hard and light and goes to the B's which are soft and dark. The ones I use the most are:

hard ◄——— 2H H F HB B 2B 6B ———► soft

Paper. I prefer a smooth, textureless paper because I like to build my own texture with the pencil. The drawings in this book were done on 11" × 14", 2-ply, plate finish, hard bristol paper which comes in a pad.

Accessories. For your drawing board, choose a piece of tempered masonite, formica or acrylic. I like my formica board best. It is extremely smooth and allows me to draw on a single sheet of paper with no grain coming through. Your board should be 16" × 20" for use with the 11" × 14" paper. You will need two large clips for attaching the paper to your board to hold it steady while you work.

I suggest using the vinyl eraser exclusively. It will not damage the delicate surface of the plate finish paper, and it erases all hardnesses of pencil completely and easily.

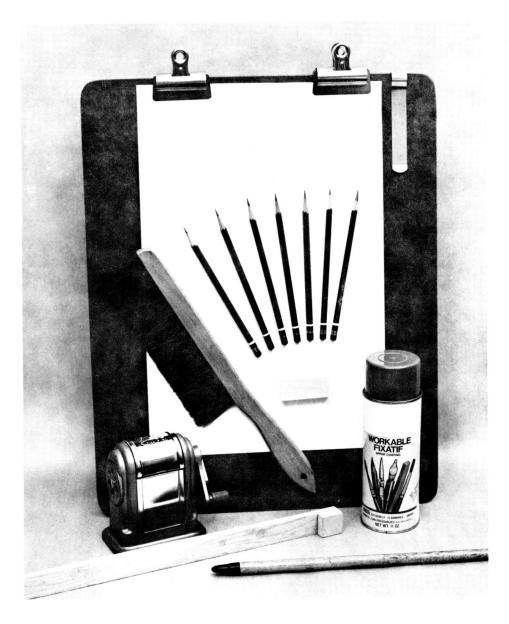

There are three ways to keep your hand off the paper while you work. One is the bridge—a small piece of wood about 1" wide with two blocks glued to each end. I prefer the maulstick, which is a light-weight piece of doweling, and typing paper which can be slipped over the working area to allow the hand to move freely across the paper.

Workable Fixative. This resin solution, available in a spray can, is designed to fix your finished drawing to the paper to prevent smudging. Several light coats of spray are better than one heavy coat. If the drawing is kept clean and framed under glass right away, spraying may not be necessary.

The Work Area

The work area need not be elaborate. Have a small table or easel against which you can rest your board in a slanted position, with the work at a right angle to your eyes. You can even use the kitchen table to get started. Here we show my board at a comfortable angle for me, with the drawing pad clipped to it. Sometimes I move the board at various angles to improve my pencil contact. Feel free to experiment. On a small table nearby I have plenty of sharpened pencils, erasers, and a sheet of typing paper for use under my hand to prevent smudging. Notice the maulstick position I am using to work on my drawing. My hand-cranked pencil sharpener is close by for quick access.

I work under a fluorescent light, which gives consistent illumination whether drawing at night or in the daytime. Thus, I am not limited by natural daylight which varies on cloudy or sunny days. I work from slides and have a rear-projection screen just to the right of my easel. This enables me to easily glance at my subject. I enjoy working from a 16 × 20 image as it allows me to observe more detail in the subject. However, pictures work well for many people. My students often drew from enlarged photos with satisfactory results. Some also used a magnifying glass.

Again, remember not to be concerned about having an elaborate set-up. Arrange the basics and get started. You can add pieces of equipment and develop your studio as you progress.

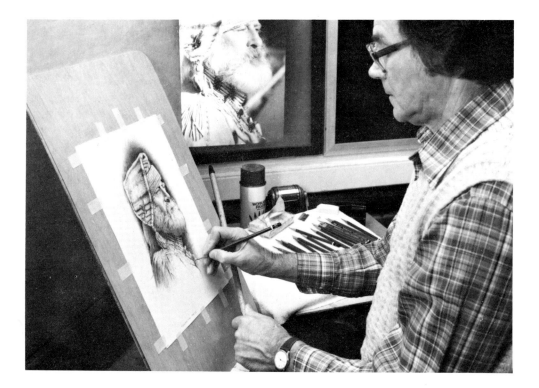

Basic Hand Positions

The pencil held in the underhand position, pictured at the right, is used for blocking in your drawing. Holding the pencil nearly horizontal to the paper, move lightly and loosely in a sketching motion, "feeling" the shape as you go. Your hand should not touch the paper at all, and you can lay in your shapes easily by swinging your whole arm. This position is also valuable for shading, as you have complete maneuverability over the pencil.

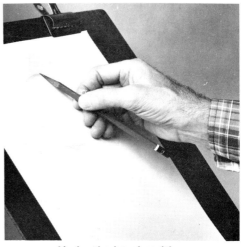

Under the hand position

You can go from the underhand to the cupped position by simply turning your hand over. This position is best for making underlines, and precise detail over the preliminary shading. This position is also good for making thick and thin lines which are made by rolling the point as you drag the pencil across the paper. Another technique called glazing can be produced with the pencil held in this position. Slip a piece of typing paper under your hand as you work to prevent smudging the drawing.

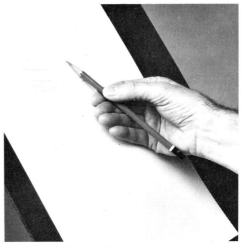

Cupped hand position

The pencil held in the writing position is used for hatching, some shading, and glazing. The writing position is always used for precision lines, and adding accents on your almost-completed drawing. When holding the pencil in this position, I like to use a maulstick.

Practice changing hand positions swiftly so that you can work from one technique to another without interruption. Also experiment with these positions to get different effects. Discover which are more comfortable for you. Maybe you will develop some of your own.

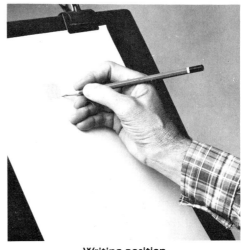

Writing position

Choosing Your Subject

Choose something you like, then you will be willing to spend time on it. Fascinating subjects are everywhere. Whatever your choice, it should have contrast in texture, light and shadow, and variety in shapes. These will provide interest in your drawing.

Animals are an inexhaustible source. Wildlife magazines contain outstanding pictures. Animal parks, zoos, and natural history museums offer opportunities to photograph your own subjects. Our county museum has a fine stuffed bird collection which I have used.

Travel with your camera handy to photograph old barns, interesting trees, decaying fences and wild flowers. Use vacations to gather subject matter. I've combed the deserts and ghost towns of our western states, and found some inspiring examples of Victorian architecture, mining tools and other western memorabilia.

Old vehicles, another interesting subject, are found in motoring magazines and auto museums. An old trolley museum near my home provided me with the Forgotten Ford.

Don't overlook your own backyard. A child's worn tennis shoe, or an old stuffed toy, such as Poohie in this book, are favorites of mine.

Consider the changing seasons. Some subjects look better in winter, such as a drift of snow on a fence rail.

Browse through antique shops and bookstores for ideas. Your public library is a vast reservoir of pictures and magazines which may be borrowed. Neighbors and relatives are good sources. They usually are pleased to lend objects you admire.

Whatever I choose to draw, it must be a subject of special meaning to me. I won't do an object just to be drawing. If I'm persistent in my search, then I'm usually blessed with a delightful surprise.

Lighting Your Subject

Whether you work from photos or from sight, proper lighting is extremely important.

Indoor Lighting. Purchase a 50 or 75 watt spotlight with a clamp-on light socket (not a floodlight as they are too soft). Use an old box or board as a backdrop. Drape it with a piece of cloth if you wish. Clamp your spotlight onto the top edge of the backdrop and adjust it to direct the light across your subject diagonally.

Move your objects around until you arrive at an interesting lighting situation. Experiment and develop the system which portrays your subject most successfully. It is good to have cast shadows across parts of your subject, and some reflected light to enhance it. Light the object in such a way as to reveal its character, texture and detail. Lighting should subdue some areas and highlight others. Look at your subject with the light turned off. Now turn on the light. See how it comes alive. A good subject can become outstanding with the proper lighting.

Outdoor Lighting. When working outdoors, the position of the sun is important. Study your scene or object at different times of day until the lighting situation pleases you. I find that when the sun is low in the sky, stronger shadows are cast, giving more contrast. These deep shadows enhance textural surfaces such as wood grains, foliage, and rock crevices. A strong lighting system adds sparkle and highlights which create a powerful picture.

Consider soft lighting for special effects. An illusive mood can be achieved on overcast days, rainy days and at sunset. This method is very good for drawing people, especially children, as it keeps them from squinting and frowning. The same mood can be executed indoors by placing your subject near a large window through which natural light is diffused.

Lighting your subject can be real fun. The more you experiment, the more creative you will become. Good lighting can make the difference between average and outstanding drawings.

Sample Textures and Strokes

Note: Harder pencils are smooth and light.
Softer pencils are grainy and dark.

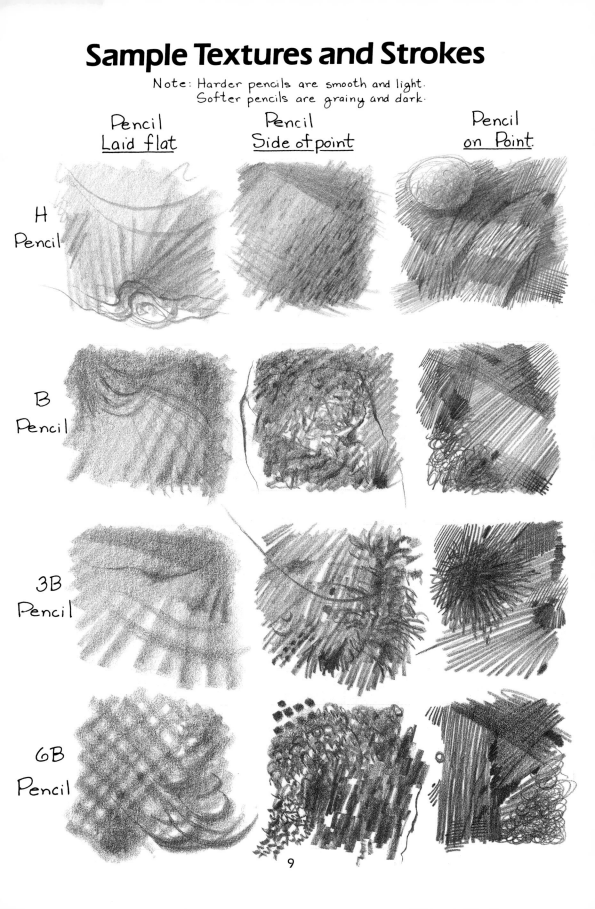

Pencil
Laid flat

Pencil
Side of point

Pencil
on Point.

H
Pencil

B
Pencil

3B
Pencil

6B
Pencil

Thumbnail Sketches

Thumbnail simply means a small, brief sketch. I call it thinking with a pencil in shorthand. The purpose of a thumbnail sketch is to give you the opportunity to put together the shapes and objects of your picture in a pleasing composition. By putting your ideas on paper, you can solve potential problems before you begin your actual drawing. Work with the softer pencils—the HB, B or 3B, as these are well-suited for sketching. They produce darks more readily. Most artists make several thumbnails, arranging the elements in various compositions, and then choose the best one.

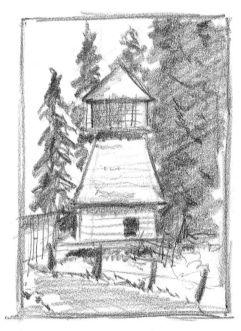

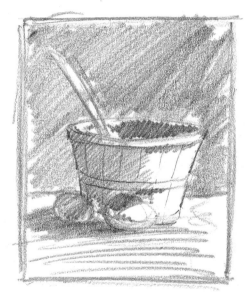

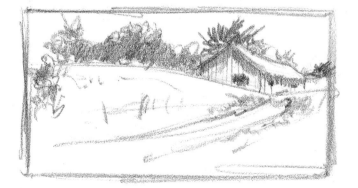

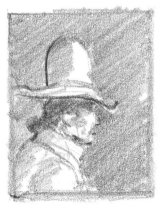

Measuring

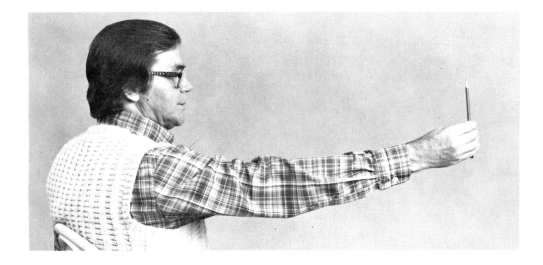

Measuring is an aid to obtaining correct proportions in your drawing. To begin, sit up straight with your back against the chair and your feet flat on the floor. Extend your arm, pencil in hand, straight out in front of you as far as possible without moving your body. Your pencil should be held vertically at eye level, with the point upright. Closing one eye, place the point of the pencil at the top of your subject and move your thumb to the bottom edge of the subject. Now, without moving your thumb, make two marks on your paper. Your first mark will be the bottom edge of your subject. Place your thumb on that mark and make a second mark where the tip of your pencil falls. You have now established the height of your subject as it will appear in your drawing. Holding the pencil in a horizontal position, measure the width, and mark your paper. Repeat this process to locate all the other major dimensions. By doing this simple exercise, you can be assured of a drawing in which the proportions are correct.

There may be times when you wish to enlarge your subject, or make it smaller. This can be easily achieved by moving your chair—closer, if you want your subject to appear larger, or farther away if you wish it to appear smaller.

This method of measuring can be used with a photograph as well as a still life. Lay your pencil right down on the photograph for measurements. Mark your paper in the same manner as explained above. If the photo is small, simply double your measurements before marking the paper.

It is important when making those first marks to consider the placement on the paper. I prefer that my subjects be slightly above the center of the page.

I think you will be pleased to see how easily you can achieve good results by adhering to this simple method of measuring.

Perspective—Cylinder Shape

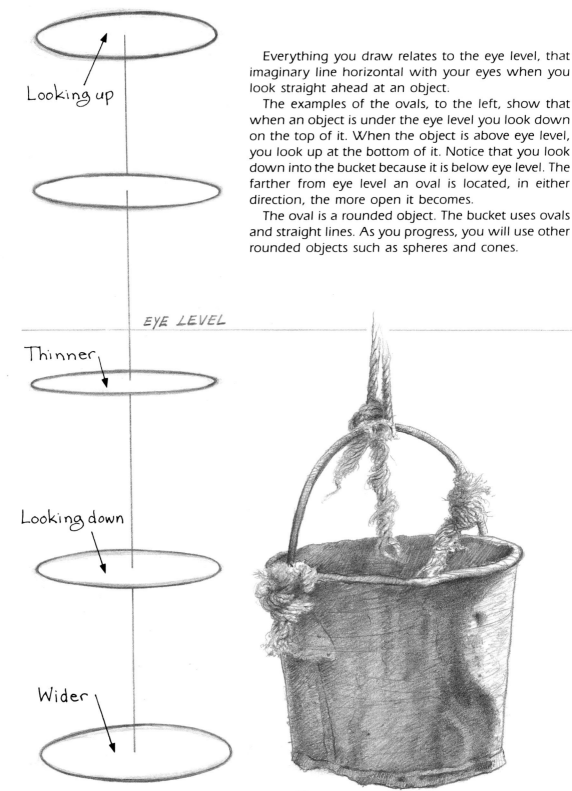

Looking up

Everything you draw relates to the eye level, that imaginary line horizontal with your eyes when you look straight ahead at an object.

The examples of the ovals, to the left, show that when an object is under the eye level you look down on the top of it. When the object is above eye level, you look up at the bottom of it. Notice that you look down into the bucket because it is below eye level. The farther from eye level an oval is located, in either direction, the more open it becomes.

The oval is a rounded object. The bucket uses ovals and straight lines. As you progress, you will use other rounded objects such as spheres and cones.

EYE LEVEL

Thinner

Looking down

Wider

Perspective—Square Shape

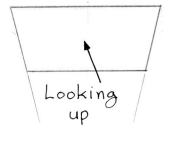

Looking up

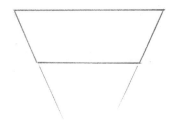

When drawing a square or cube, you must observe the foreshortening rule. As illustrated by the coffee grinder, the corner nearest you appears longer than the corner farthest away.

Notice that the parallel lines of the coffee grinder appear to get closer together as they go farther back. If continued far enough they would eventually merge at eye level on a spot called the vanishing point. You can always check your perspective by seeing if your parallel lines merge at the same spot.

As with the bucket, you look down on the coffee grinder because it is below eye level.

The principles illustrated on these two pages will help you with most perspective problems.

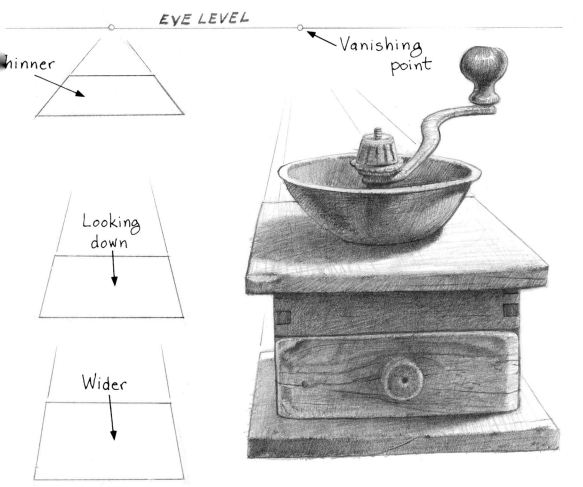

EYE LEVEL

Thinner

Vanishing point

Looking down

Wider

Handling the Pencil

Pencil drawing is a personal medium. It is basically an individual effort of self-development through practice. It is a moment-by-moment decision-making process in which you learn by doing. I do not like a mechanical approach to the study of drawing. However, it is necessary to train your mind to observe and adhere to certain known principles that must be followed in order to produce a satisfactory pencil drawing.

Hardness of Leads. Have several pencils of various hardnesses handy. In each hardness, have one with a sharp point, one with a ball point and a third, quite blunt. In this way, you can switch back and forth instantly to get desired effects. For example, if you have two or three F's in different degrees of sharpness, you can do practically a whole drawing with just these pencils. The function of the different hardnesses is most important. Hard leads are used at the beginning to establish your precision drawing. They are also used at other times to make thin lines and shade lightly. For minute detail, a sharp pencil should always be used. It is important to avoid switching to the soft leads too soon, or you will destroy the subtle effects you are trying to develop. Soft leads are used for darker details and shading. They tend to be grainy, so to avoid the graininess work on the point or go back to a harder lead. Soft leads are used towards the end of your drawing for deep contrast. Remember, "it takes the darks to bring out the lights." Developing those darks transforms an otherwise bleached-out drawing into one with power and dimension.

Position of the Pencil. The way you hold your pencil is as important as what you do with it. Held in a very flat or laid down position, you can easily sketch in the shape of your subject. This position is also good for general shading when you want a grainy look. Holding the pencil up a bit more, on the side of the point, you can get more minute detail. This is a good position for lighter shading and for enhancing other tones. It is also used for softer effects when the side of the tip has become slick and flat. Finally, the pencil held all the way up on the point will produce fine lines often used on top of glazing and excellent for hatching. You get a smoother effect with the pencil held this way when the point becomes blunt. These effects will add variety in texture and interest.

Sharpening the Pencil. I used a regular pencil sharpener when I produced the drawings in this book. This is my favorite method. However, many art students prefer to use a single-edge razor blade to peel away the wood, exposing about a half-inch of lead. They then rub the lead on a sandpad to make it pointed.

Pressure. The amount of pressure placed on the pencil is very important. Bear down and make darker strokes. Let up, run the pencil back and forth against the paper with medium-light pressure, and a continuous transparent tone will result. Many of my students were surprised to discover that by changing the pressure on their pencils, they could achieve desired contrasts of tone.

Variety of Strokes. Mass toning is the technique whereby you lay the pencil down and shade with the long shank of the pencil lead. It is general, smooth or rough shading over a large area that you are developing here. You will want to use a ball point pencil for light, smooth shading.

Hatching is the stroking of the pencil on the point to produce short, fine, parallel or criss-cross lines. It is essential to use this stroke when added texture is needed. A sharp pencil is used for hatching.

Glazing is accomplished by shading thin layer over thin layer, working from light to dark. It should be used when a transparent film needs to be laid over under-strokes. A blunt point held in the writing position, run quickly back and forth over the paper, is best for laying in a smooth glaze quickly.

Action strokes are achieved by sweeping the arm back and forth, holding the pencil underneath the hand. These strokes are used for feeling the shape of your subject in a loose sketch.

Depth and Atmosphere. We need to consider depth in our drawing; that is, how to give it a three-dimensional effect. In the foreground, sharp, large texture and dark shading will make things appear closer. Sharp underlines and edges, such as those on the edge of a nose or eyelid, or a hat brim, bring that element forward on your paper. On the other hand, if you soften lines and edges, such as the neck area under the chin, they recede. Soft texture and light grays in a bleary mode give distance and depth. I've had people look at my drawings and say a nose or a hand seems to come out off the paper. It is simply a matter of using glazes, texture and underlining in the right places. Accenting little dark areas of your drawing adds sparkle.

Size of drawings. Beginners should stay with small sizes at first. You may work a very small miniature or a large picture. Sizable pictures will use large, blunt leads and bolder strokes, while the smaller pictures will need sharper pencils.

After a lifetime of drawing, I still have to "re-learn" each time I do a new subject. I have to think out my project as I work. However, since I have a trained thought pattern in handling my tools, I am able to get professional results the first time. You can do it, too. At every opportunity doodle and exercise. Draw ovals and squares. Copy the strokes and projects in this book. Learn to think with your pencil. In time, as you faithfully practice, you will become proficient in handling the pencil.

The Value Scale

The lights and darks of a picture are known as the values. A scale of nine values ranging from white to black has long been established. A good drawing should contain several of these in order to show satisfactory results. A more detailed and finished drawing will utilize a wider range of grays.

Study the step drawings in this book to see how the progression from light to dark takes place. Notice how the values are developed and how they become more powerful as the final darks are added.

Developing the Projects

There are many methods of pencil drawing. In this book, I convey my system of developing a drawing from start to finish. This approach has worked well for me and for hundreds of my students. It is not a formula to follow to the letter, but a set of steps to help you get started.

An art tool behaves differently in the hand of each student. You will find that your drawings will have your unique interpretation. That's the way it should be. Learn to be happy with your own results and say to yourself, "I'll do better next time."

Begin by "feeling" the shape of the subject, loosely and lightly, in a sketching manner, with the pencil held under your hand. Keep it light so you will not need to erase and damage the paper. These lines should disappear as you do your shading.

Next you begin to refine your line drawing. In this step, you will be developing the actual outlines of the subject right over your exploratory shapes. Feel free to change your hand position as necessary for desired results.

It is important, as you begin shading, to establish the patterns of your darks. Begin with harder leads progressing to the softer ones. This is subject to variation, though, depending upon the desired effect in a given case. As I've said before, have several pencils handy. Keep alert. If your pencil is not doing the job, switch to a different one. After doing some preliminary shading, progress to the secondary shading. Lay in thin layer over thin layer. With a sharp pencil held in the writing position, reinforce your line drawing as necessary, to avoid losing it.

As you advance to the last step of your drawing, continue to darken areas adding final accents, again using a sharp pencil. Keep in mind as you proceed with your drawing, that it should become gradually darker and take on more contrast.

As you thumb through the following pages, you will see that a variety of subjects has been chosen. Each one teaches a different aspect of drawing, from the simple oval of the egg to the complex vehicles and portraits at the end of the book. For example, the kitten and colt emphasize the technique of drawing animal hair. In the study of the sparrow you will focus on feathers. The wagon gives an opportunity to practice the texture of the wood, and the mountain man offers a rich variety of fabric textures.

I encourage you to practice these subjects. If you have trouble doing a certain one, then go back to the basics. Practice your doodles. Do textural effects. It is just a matter of learning each step thoroughly, before you tackle the next.

Some of the projects may be more difficult than you have attempted in the past. You need these examples to inspire you to strive in improving your own techniques. If you have some ability and a desire, then you can teach yourself to draw in this step-by-step self-development system.

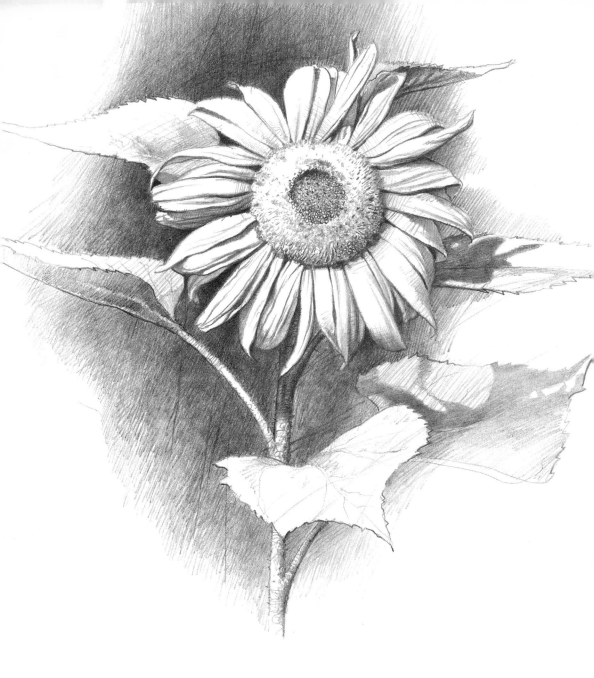

Still Life

Project 1. Walnut—Textured Surface

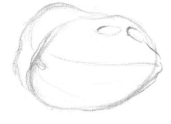

1.

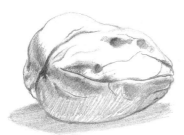

2.

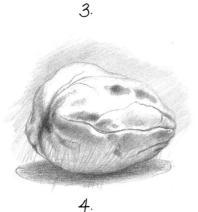

3.

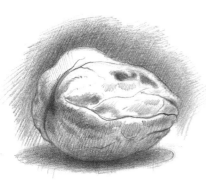

4.

5.

<u>Step 1</u> – Use a loose motion with the H pencil held under your hand, feeling the oval shape.

<u>Step 2</u>- Holding your H pencil in the cupped hand position, begin identifying the actual shape of the nut.

<u>Step 3</u> – Using the side of the point, continue with your H pencil in the cupped hand position. Begin to develop the preliminary shading by bringing in some darks with the F in a blunt attitude. In this case, the shading is started before completing your line drawing. Reinforce the lines with a sharp F held in the writing position.

<u>Step 4</u> – Continue shading the undeveloped areas with your HB. Lay in the shadow behind your nut to give it depth.

<u>Step 5</u> – Darken the shaded areas still further with a blunt HB, accenting crevices with a sharp HB. Develop the shadow behind your nut still further to bring out highlights.

Project 2. Brown Egg—Smooth Surface

1.

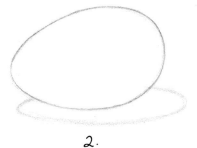

2.

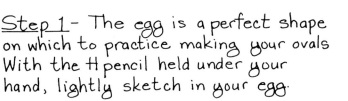

3.

Step 1 - The egg is a perfect shape on which to practice making your ovals. With the H pencil held under your hand, lightly sketch in your egg.

Step 2 - Refine your oval by making a precise line drawing with the point of your H pencil.

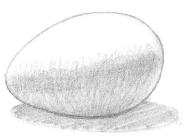

4.

Step 3 - Holding the H under your hand, lay in the primary shading using the side of the pencil point.

Step 4 - Shade lightly with your H in the cupped hand position. Bring in the secondary shading by laying thin layer over thin layer with the side of the point. Begin to develop your shadow behind the egg. Come in with your F pencil in the same manner.

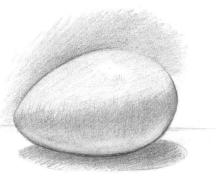

Step 5 - Work with your ball point F in the writing position. Deepen the shading. Complete your egg with some speckles to give it texture.

5.

Project 3. Strawberry Basket

2.

1.

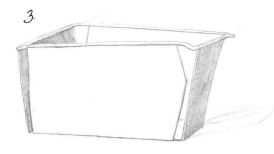

3.

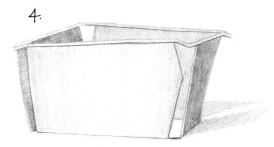

Steps 1 and 2 – Draw lightly with the 4H pencil laid down under your hand.

Step 3 – Use your 4H on a sharp point to put in the fine, straight details of the line drawing. Begin the shadows with your 2H.

4.

Step 4 – Continue to shade with the H pencil on a blunt point. Add accents with the F.

Step 5 – Complete the dark areas by glazing several coats with the F. Make the sharp final accents, such as grain of the basket, with a pointed F. Add some free strokes to loosen up your drawing.

5.

Project 4. Old Wheel Hub

First - measure and make marks. Establish placement of drawing on paper.

Second - sketch ovals and dimensions lightly.

Step 1 - Feeling the Shape

Block your drawing in holding the 2H pencil under your hand, sketching lightly.

Slide your hand, pulling the pencil along to make curved lines.

Outline each element.

Step 2 - Precision Line Drawing

Using the 2H pencil, begin to develop a very accurate, detailed drawing.

Using the H pencil on a blunt point, develop your medium light tones blended to very light on the edges.

With your F pencil on a semi-blunt point, establish your dark crevices to prevent losing detail during shading.

Step 3 - Preliminary Shading

Using the H and F pencils with your hand resting on the bridge or maulstick, develop the shading.

Step 4 - Secondary Shading

Continue working with your F and HB pencils, applying a little more pressure to darken down the under-developed areas.

Continue to darken medium tones with your F pencil.

Enhance the dark areas with a sharp F pencil.

Step 5 – Finished Drawing

Using the B and 2B pencils, darken the drawing to its final finished form.

Old Wheel Hub

The old wheel hub is a favorite of mine because it speaks of our nation's history and shows the necessity of order — a hub is that which holds the wheel together and makes it turn.

Project 5. Poohie

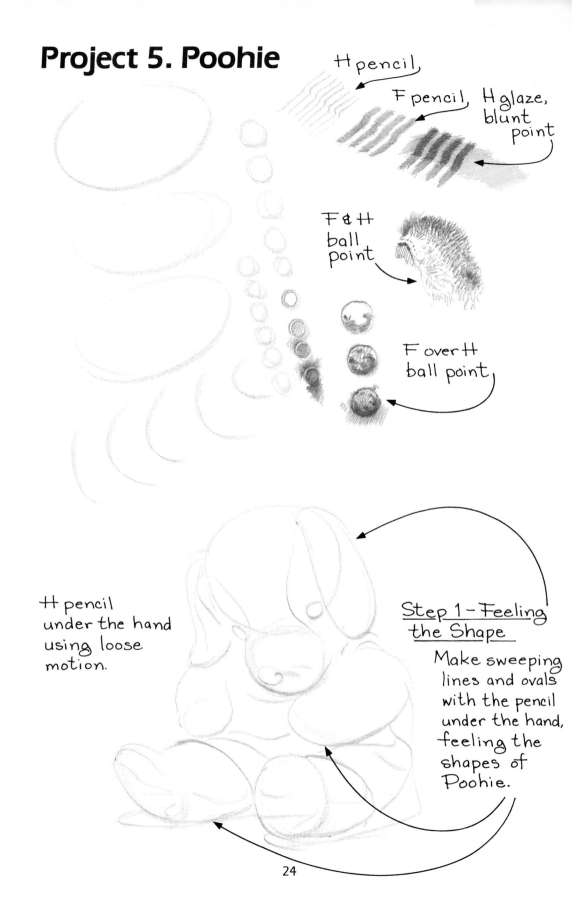

H pencil,

F pencil, H glaze, blunt point

F & H ball point

F over H ball point

H pencil under the hand using loose motion.

Step 1 – Feeling the Shape

Make sweeping lines and ovals with the pencil under the hand, feeling the shapes of Poohie.

Hold the pencil under the
hand and slide along
on the side of the
point.

Roll the point
to get thick
and thin.

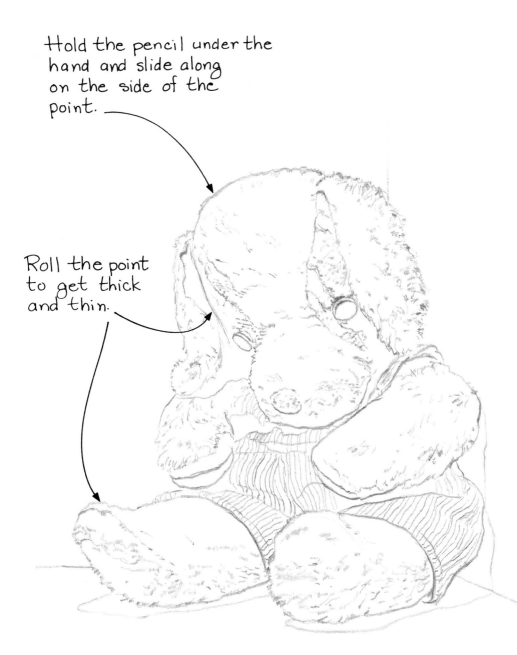

Step 2 - Precision Line Drawing

Using the H pencil, refine the shapes
into a detailed line drawing. Outline
all of the elements on the side of
the point. Most of these lines will
vanish during steps 3 and 4.

Step 3 - Primary Shading

Using the F pencil on a ball point, bring in the darks, steadying your hand on the maulstick.

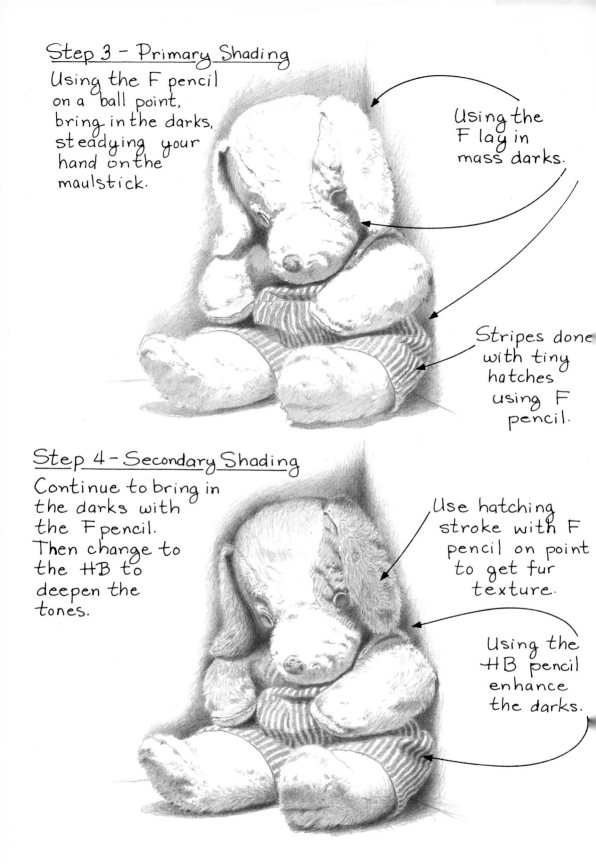

Using the F lay in mass darks.

Stripes done with tiny hatches using F pencil.

Step 4 - Secondary Shading

Continue to bring in the darks with the F pencil. Then change to the HB to deepen the tones.

Use hatching stroke with F pencil on point to get fur texture.

Using the HB pencil enhance the darks.

Step 5 – Finished Drawing
Using the HB and B pencils complete your final shading.

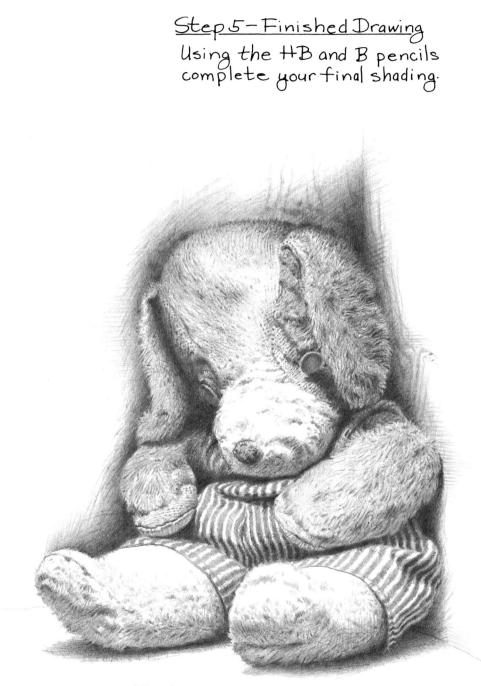

Poohie

This well-worn toy, a favorite of my 23-year-old daughter's childhood, was a most popular classroom still life object with many of my drawing students.

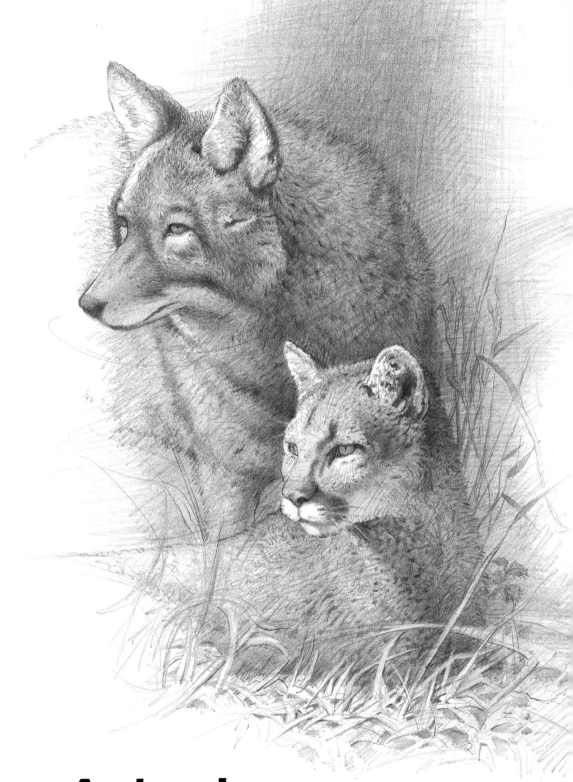

Animals

Project 6. Calico Kitten

Step 1 – Feeling the Shape

Working with your 2H pencil, make your ovals of the kitten's head and body, holding the pencil under your hand.

Step 2 – Precision Line Drawing

Continuing with your 2H pencil, work the shape, defining areas of detail as you go. Learn to roll your pencil held in the cupped hand position, to provide thick and thin lines for emphasis.

Step 3 – Preliminary Shading
Using your H pencil, lay in the
darks in medium tones.

Step 4 – Secondary Shading
After the patterns of the fur are established,
go in and darken areas with your F pencil.
Start to bring in the detail of the fur by
making short hatching strokes with
a sharp point held in the
writing position.

Step 5 – Finished Drawing

Continue to darken with your F & HB pencils. You will find that animal hair is well-suited for pencil.

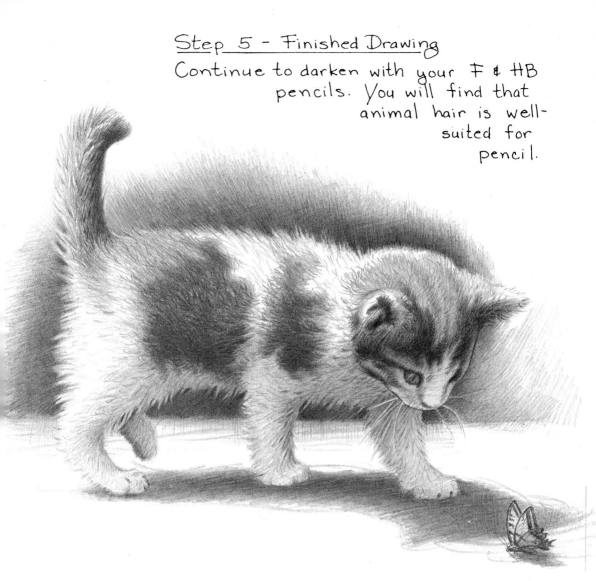

Calico Kitten

This frisky kitten, one of a litter I photographed, provided several hours of entertainment and challenge. The little ball of fur was constant motion, but I finally managed to get this cute pose in a split second before it turned its head.

Project 7. White-Throated Sparrow

Step 1 –

Feeling the Shape

Use the H pencil in a circular motion, laid flat and held under the hand.

Step 2 – Precision Line Drawing

Make the contour lines with an F held under the hand.

Roll the pencil for a thick and thin effect.

Use writing position, too.

Step 3 – Preliminary Shading

Define feathers with F pencil. Lay in darks. Begin shading.

Start to bring in the twig.

Step 4 - Secondary Shading

Using F and HB
pencils.

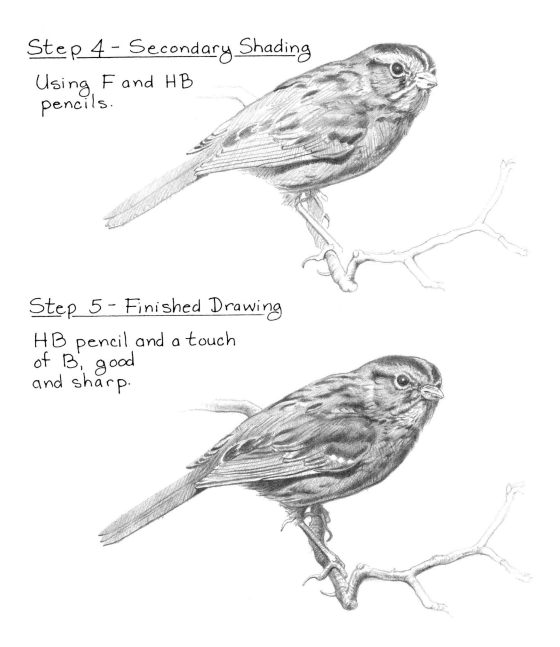

Step 5 - Finished Drawing

HB pencil and a touch
of B, good
and sharp.

White - Throated Sparrow

In winter, the sparrows gather outside my
studio window in an old sycamore tree.
They inspired this drawing of a good specimen
from the local museum.

Project 8. Looking Back

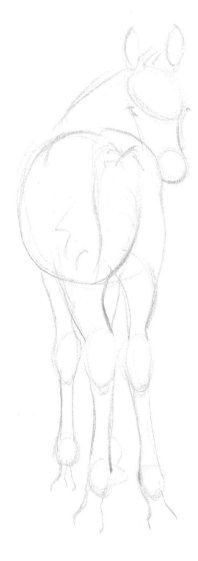

Step 1 – Feeling the Shape
This little colt gives you
a good opportunity to
practice your ovals. Using
the 2H pencil held under
your hand loosely sketch
in the rump, head, and leg
joints. You might try
laying a piece of tracing
paper over my drawing.
Trace the lines over and
over, loosely, until the
motion becomes
spontaneous.

Step 2 – Precision Line Drawing

Now go back over your ovals and reinforce the lines with your H pencil. Thick and thin lines can be made by rolling your pencil and bringing it up on the point while holding it in the cupped position. Don't be afraid to make some sharp lines with your pencil held in the writing position. Concentrate on changing the positions of your pencil as needed. This should become routine.

Step 3 – Preliminary Shading

Using your H with a ball point, in the writing position, lay in the dark areas. Work on your maulstick to keep your hand off the paper. Reinforce the line drawing as necessary.

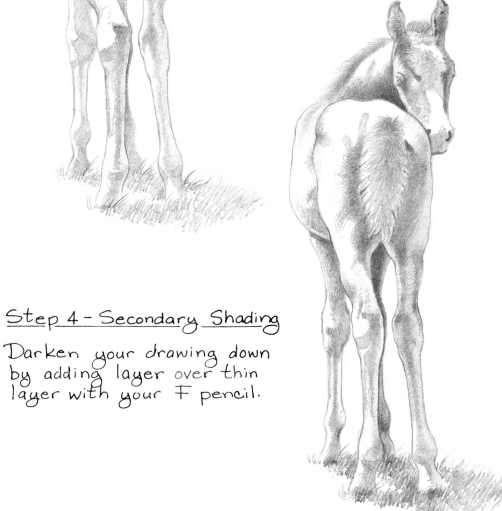

Step 4 – Secondary Shading

Darken your drawing down by adding layer over thin layer with your F pencil.

Step 5 - Finished Drawing

Continue to refine and darken
your drawing using the HB
pencil.

Looking Back

This little guy was camera-
shy. He kept running away,
but during his retreat he
provided me with the best
pose ever. He looked back
over his little rump,
and how could I
resist that!

Landscape Elements

Project 9. Indian Country

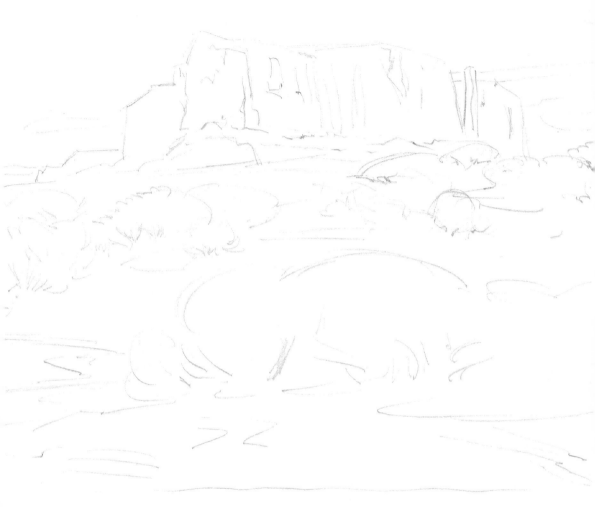

Step 1—Feeling the Composition

I chose this landscape because it is typical of the vast American West. Many places are still beautiful — a credit to the Indians who roamed these deserts for centuries and passed them on unchanged to succeeding generations. I enjoy the rugged character of this land which lends itself to pencil drawing.

Be free and easy as you roughly feel out the shapes. Establish the foundation here. You will refine it in the next step.

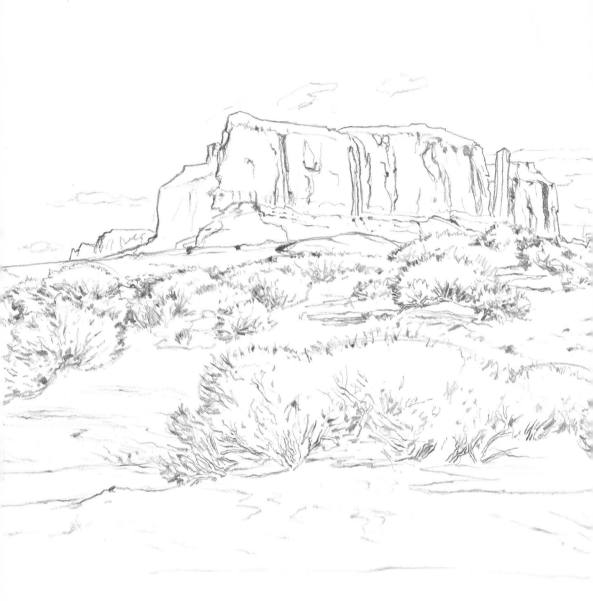

Step 2 - Precision Line Drawing

Here you will begin the detail, and give the rough forms more identity. Bring in the lines with your pencil held under the hand, rolling it on the side of the point for more expressive handling. The heavy lines on the side of the mesa were obtained with the pencil held in the cupped hand position, again rolling on the side of the point. This strong contrast adds dimension to the drawing.

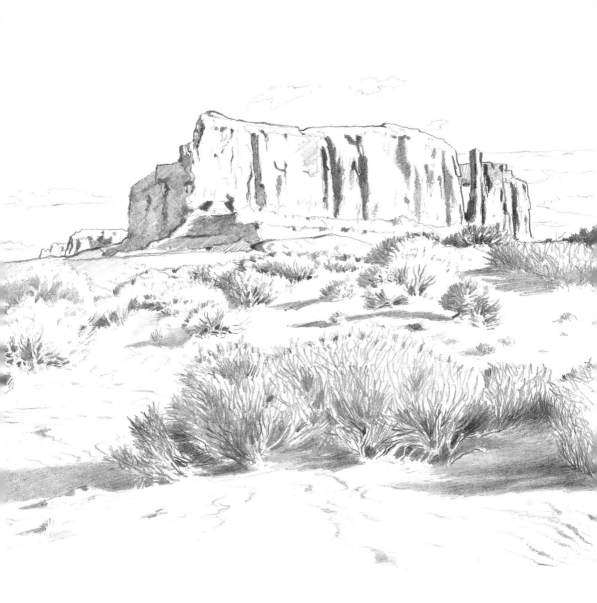

Step 3 - Preliminary Shading

Pencils H and F were used to establish the darks in medium tones throughout the composition. With well-placed shadows you can create a sense of light falling across the picture, early in the rendering process.

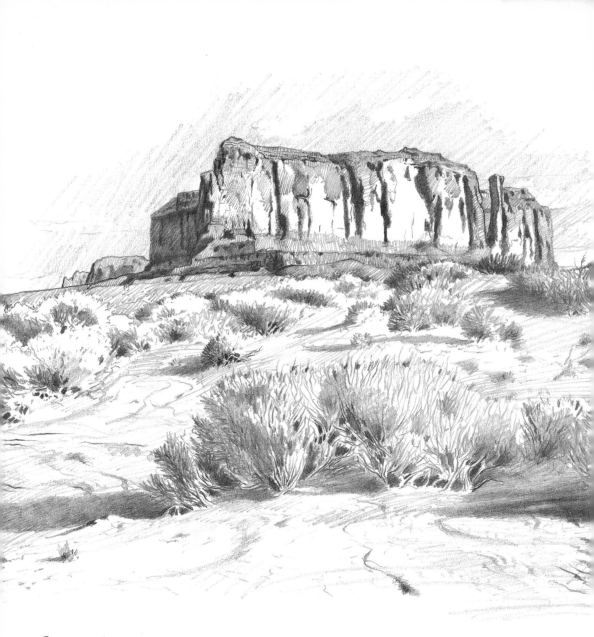

Step 4 - Secondary Shading

The H pencil used with heavy pressure is good for modeling the mesa. Use hatching strokes for medium shading on the lighted front of the cliffs. Once established, move on to the desert floor and sunlit foliage, bringing in more detail and shading.

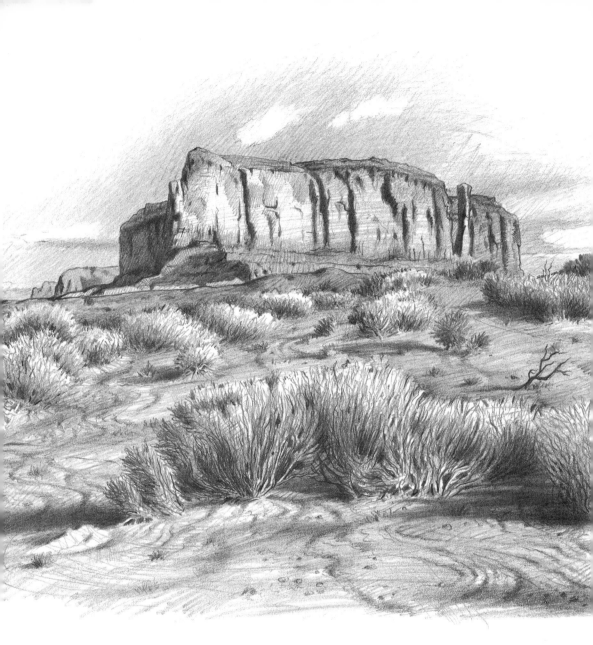

Step 5 - Finished Drawing

You can make the picture come together by forcing the darks in the background bushes and by creating some crevices in the sand. Use sweeping lines to induce movement in an otherwise uninteresting area. Use your H and F for most shading, and the B for final darks.

Project 10. Little House

Step 1—Feeling the Shape

This little southern log cabin takes me back to my country childhood where I often roamed through such deserted places. The inner walls were lined with yellowed newspapers — insulation against the winter cold. Of special fascination to me were the wooden thresholds worn thin from generations of footsteps passing over them. With your 2H pencil, roughly lay in the shapes concentrating on composition.

Step 2 - Precision Line Drawing

Over the rough lines develop your drawing with more
precise detail. For heavier lines under the roof and fence
rails, roll the pencil on the side of the point. Use your H
along with the 2H for these accents.

Step 3 – Preliminary Shading

Work on the maulstick with your H and F pencils alternately. Use your H with a semi-blunt point for medium tones and your F for darker tones. Do some spot testing on the grass, trees and fence rails. When you have a "feel" for what you are doing, let it spread over the rest of the picture. Notice how the drawing starts to come alive.

Step 4 - Secondary Shading

Continue to spot test. Reinforce lines as you go. With your F, hatch to give texture, and glaze over with a blunt point. Be alert to what is taking place under your pencil, and let it happen. Begin bringing in darks with your HB.

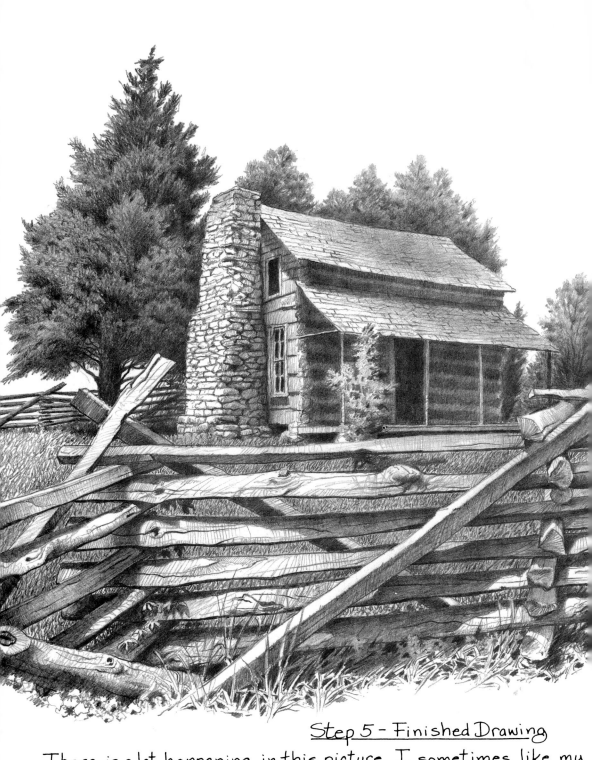

Step 5 - Finished Drawing

There is a lot happening in this picture. I sometimes like my drawing filled with a mass of varied textures and design. Finish by hatching with your HB and glazing over with the F. Accent the strong blacks with your B.

Project 11. The Wagon

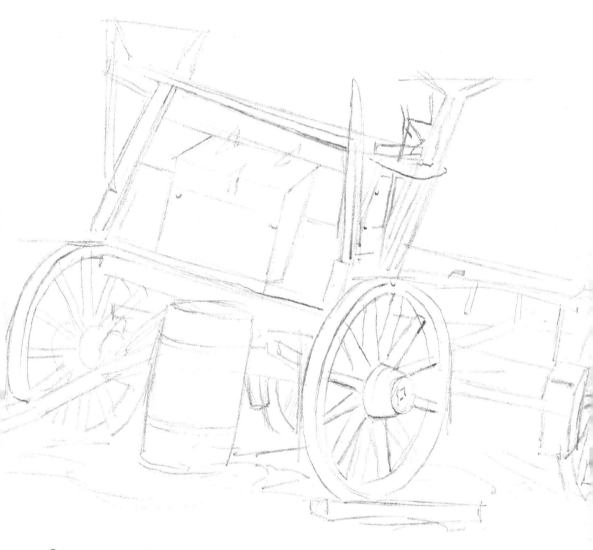

Step 1 - Feeling the Shape

When drawing a difficult subject like this wagon,
it's best to think in simple shapes at first.
Attempt to capture the overall dimensions loosely.
Try not to commit yourself to absolute detail
too soon.

Step 2 - Precision Line Drawing

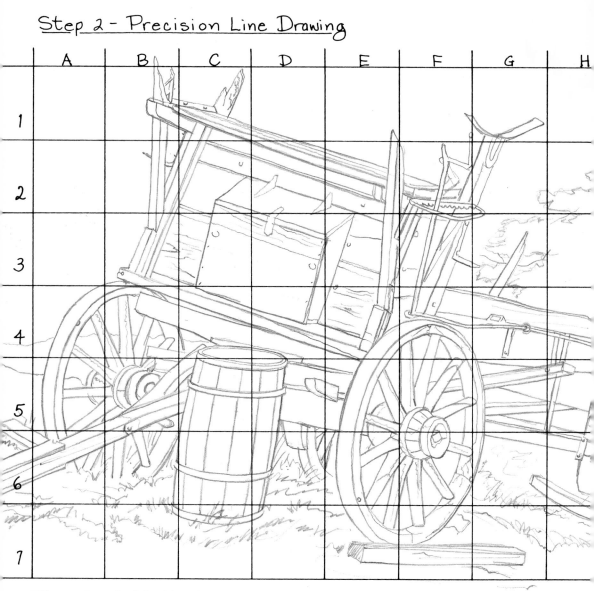

The Grid Method

A good way to enlarge pictures and ensure correct proportions is to use the grid method as illustrated above. Trace your subject darkly on tracing paper with a sharp pencil. Lightly draw ½" or 1" squares over your tracing. On a clean piece of tracing paper, draw larger squares. Number and alphabetize the blocks on your new sheet as shown above. To reproduce your subject look at the original and copy the lines in each block exactly as they appear. Finally, trace your enlarged picture onto plate finish paper, and finish your drawing.

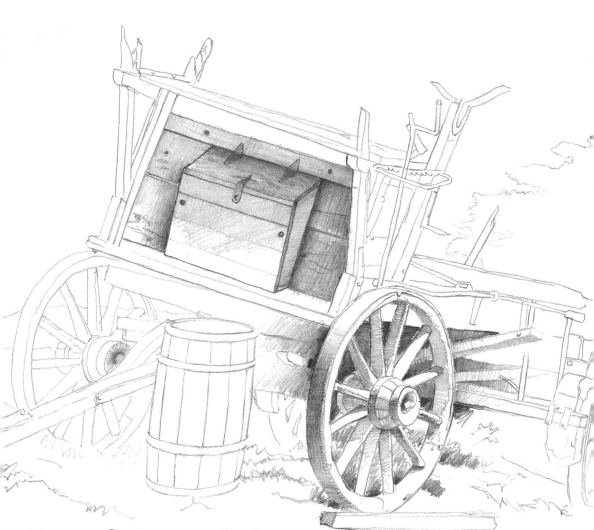

Step 3 – Preliminary Shading

For the <u>wheel</u> I used the F for darks behind the spokes, and the H for shadows on the rim and spokes. I left it simple so you could see how to start. Remember to try blunt, ball and sharp points. Discover which is most comfortable for you.

On the <u>tool box</u> there is three-dimensional detail in shadow. Keep the tones medium and thin by layering. Shade with your H and glaze with the 2H on a blunt point. You can make this box jump off the paper! Accent with your sharp F and glaze again with the 2H, a good glazing pencil for atmosphere and depth.

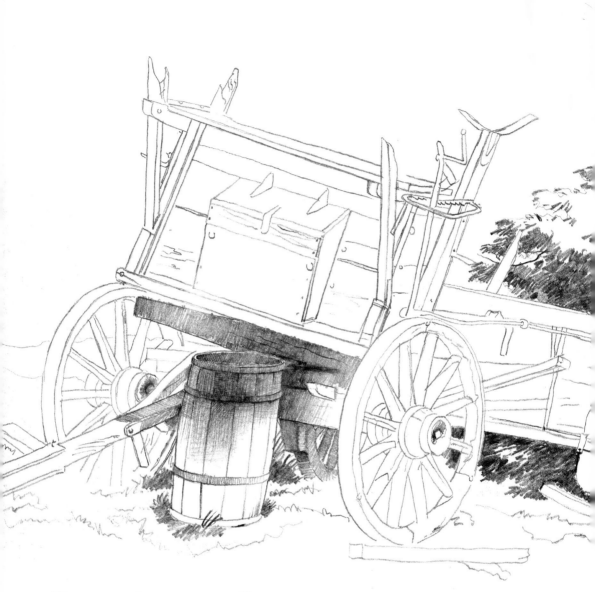

Step 4 - Secondary Shading

Use your 2H and H to give you the transparency needed to bring the nail keg forward. Switch back and forth. You will see that you can make it look round and stand out from the wagon. The harder pencils give more depth through glazing.

For the trees start with your blunt F and make each stroke in the direction that leaves grow. Reinforce with your HB.

Observing my finished drawing carefully, and referring to the isolated spot renderings will show you how to put the wagon together.

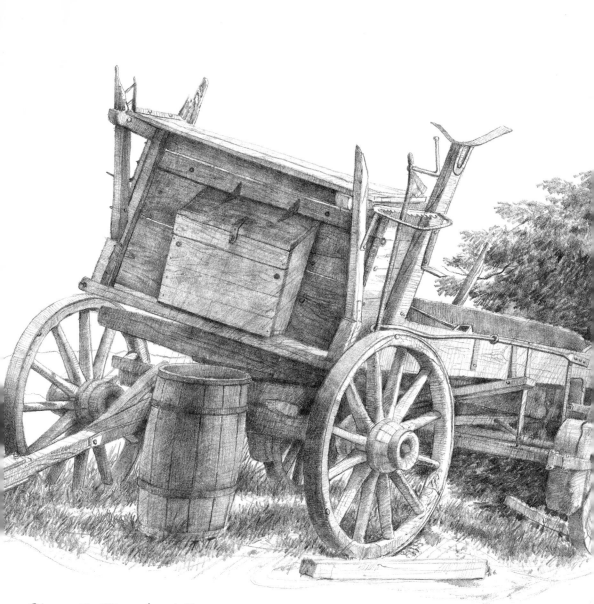

Step 5 - Finished Drawing

I have drawn a lot of wagons because they represent to me the wonderful experience of growing up in the country. This slow, dependable method of transportation offered a time for thought and dreaming — an opportunity to see and study the beauty of nature around me. I'm glad I was there to have lived during the changing of an era — a time that was fading into history.

Project 12. Forgotten Ford

Step 1 - Feeling the Shape

Measure the overall dimensions of the truck and mark your paper. Using the 2H pencil held under your hand, block in the elements lightly. These lines should disappear when you do your rendering. Loosely indicate the headlamps, windshield, fenders, radiator, etc. Note the ovals, squares and triangles in all of these elements. In this step you are preparing a foundation for your line drawing.

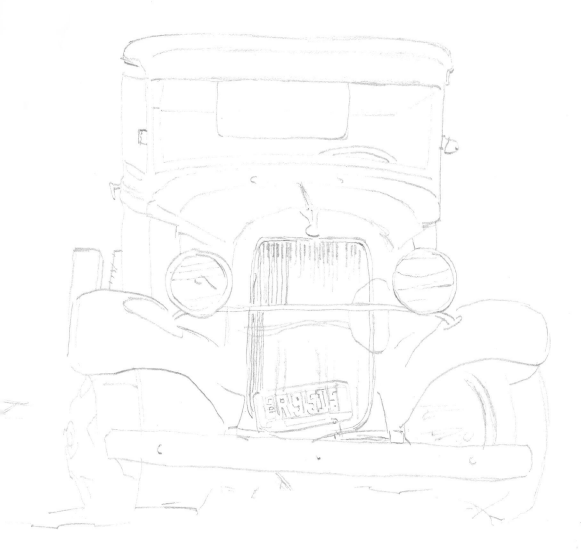

Step 2 - Sketched Line Drawing

With your 2H pencil, identify the shapes of the
elements in your subject more distinctly. Notice
the steering wheel, back window, and lines on the
radiator. Begin to tie the shapes together with
more detail. The old truck is beginning to take
on some of its character now.

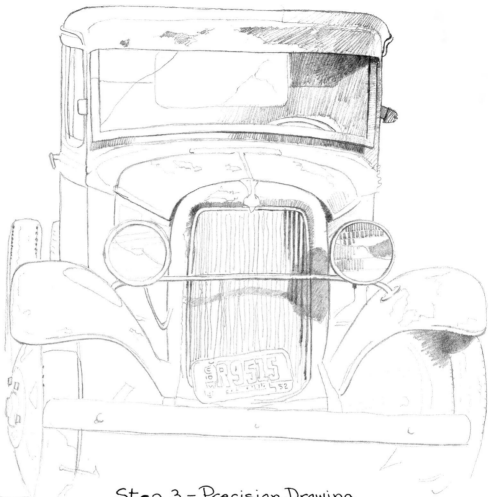

Step 3 – Precision Drawing and Preliminary Shading

In this step you will make the lines of the truck flow together. After perfecting your line drawing, turn your attention to my Finished Drawing (Step 5) as you begin to shade. Start your shading with the H pencil. Do spot tests, such as the hatching in the headlamp demonstrated above, to get you underway. It is best to work on small areas to avoid being overwhelmed by all the detail. Continually refer to Steps 3 and 4. You will see, once started, how quickly you will get the knack, if you concentrate on one section at a time.

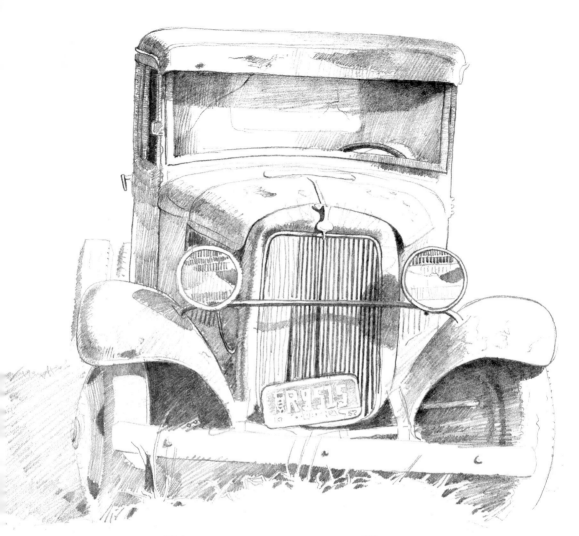

<u>Step 4 – Secondary Shading</u>

Switching to the F pencil, continue your shading.
Indicate the mass shadowed areas and add more
detail. Bring out the grass and license plate clearly.
Glaze over areas already worked. Change to the HB
for final darks (Step 5) using some loose hatches here
and there to relax the feeling of your piece – to make
it more artful. Accents such as cracks in the windshield
and splotches on the paint add character to your drawing.

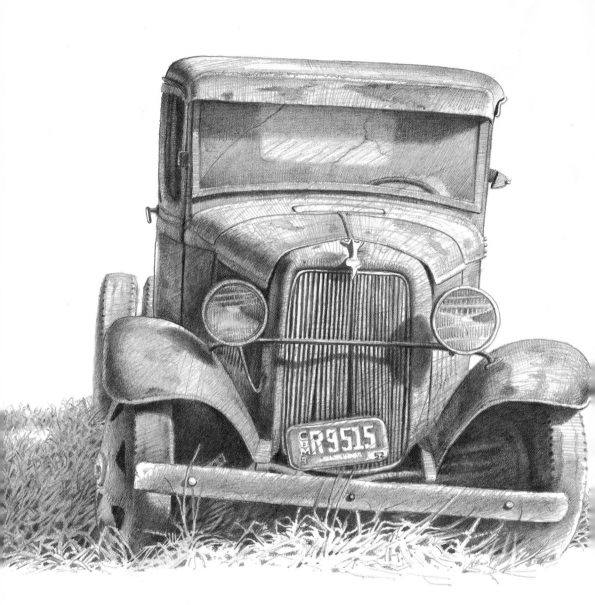

<u>Step 5—Finished Drawing</u>

A time-worn subject speaks of endurance. That's why I loved this laid by Ford truck that I discovered in a trolley museum back lot. The 50-year-old relic may have provided years of service to some diligent laborer. Perhaps it ran thousands of miles over our highways when they were not super! The picture of dependability that it evokes reminds me of the strong traits that are part of our American heritage.

People

Project 13. Mountain Man

I was able to photograph this modern-day mountain man during an authentic rendezvous at a California ghost town. I was drawn to him for what he represents — a skilled woodsman, expert in wilderness survival — an iron-willed pathfinder who blazed new trails across the wilderness. It was men like this who left their permanent mark on the colorful history of the American West.

Step 1 - Feeling the Shape

With the 2H held under the hand, lay in the shapes roughly.

Step 2 - Sketched Line Drawing

Working with the 2H pencil in the cupped hand position, begin to identify the elements in your subject more clearly.

60

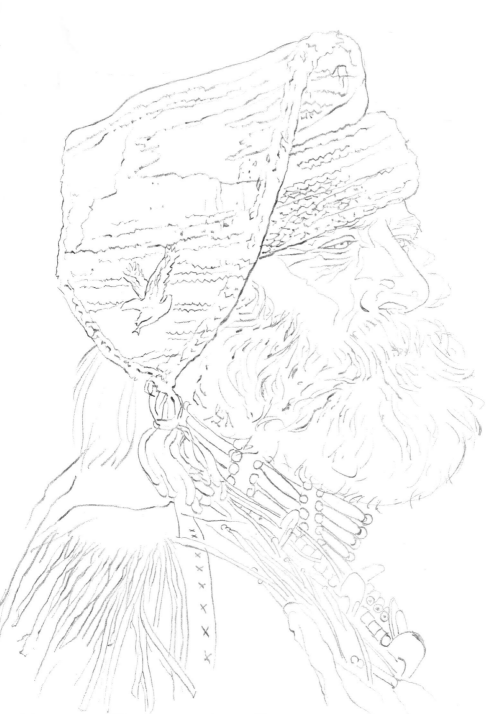

Step 3 - Precision Line Drawing

This step is done with the H pencil in cupped and under hand position. Try rolling your pencil to get more expressive lines.

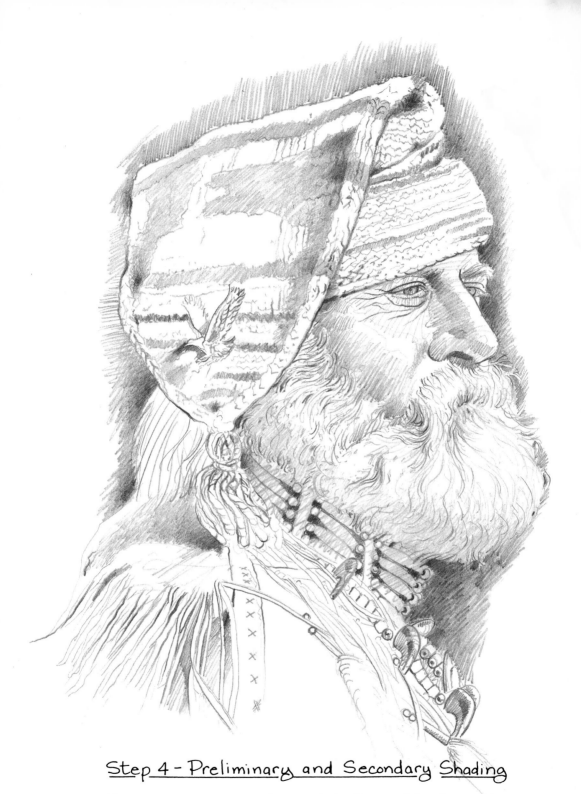

Step 4 – Preliminary and Secondary Shading

Use F and H pencils with ball and blunt points held in writing position.

Step 5 - Finished Drawing

Darken your drawing with the HB and B pencils. Glaze with H pencil over areas already worked.

My Heartfelt Thanks...

To Walter Foster Art Books who afforded me this opportunity to share some of my art experiences.

To my wife, Jane, who endured with me in collecting and writing my thoughts; who artfully hand-lettered the drawings; and who gave me her support throughout the project.

To good friends who encouraged me and provided subjects, photos, and models for several of these drawings.

To my students who for years upheld me by filling my classes, and who challenged me to grow. It was a fruitful time of developing our techniques together, and provided the experience that enabled me to do this book.

To the readers I hope these pages will inspire. I trust that wherever you are in your journey, this book will assist you in getting there faster and in a more rewarding way. Above all, that it will lift your horizons to new possibilities in your own drawing techniques, and that it will urge you to keep on keeping on.

"I dedicate this book to Tory, Terry and Cathy."